Secret Eden

anti-stress art therapy colouring book
by Christina Rose

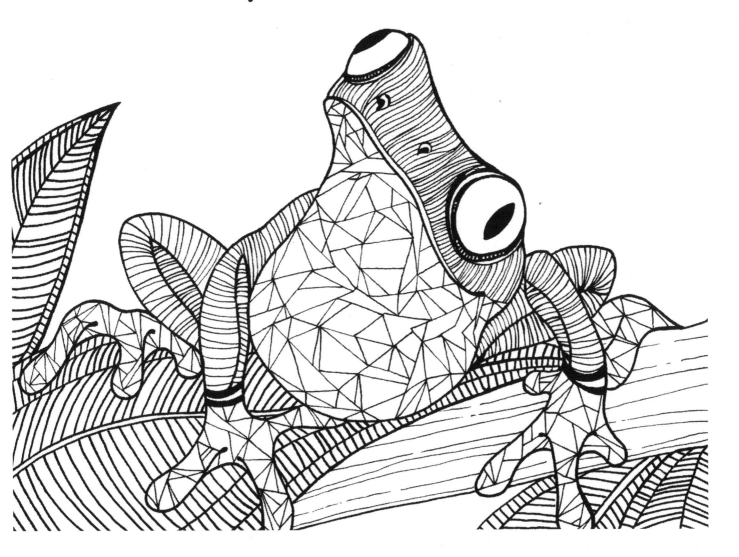

Secret Eden
anti-stress art therapy colouring book

First published in the United Kingdom in 2015 by
Bell & Mackenzie Publishing Limited

ISBN: 978-1-910771-36-5

A CIP catalogue record of this book is available from the British Library

Created by Christina Rose
Contributors: Laura Vann

www.bellmackenzie.com

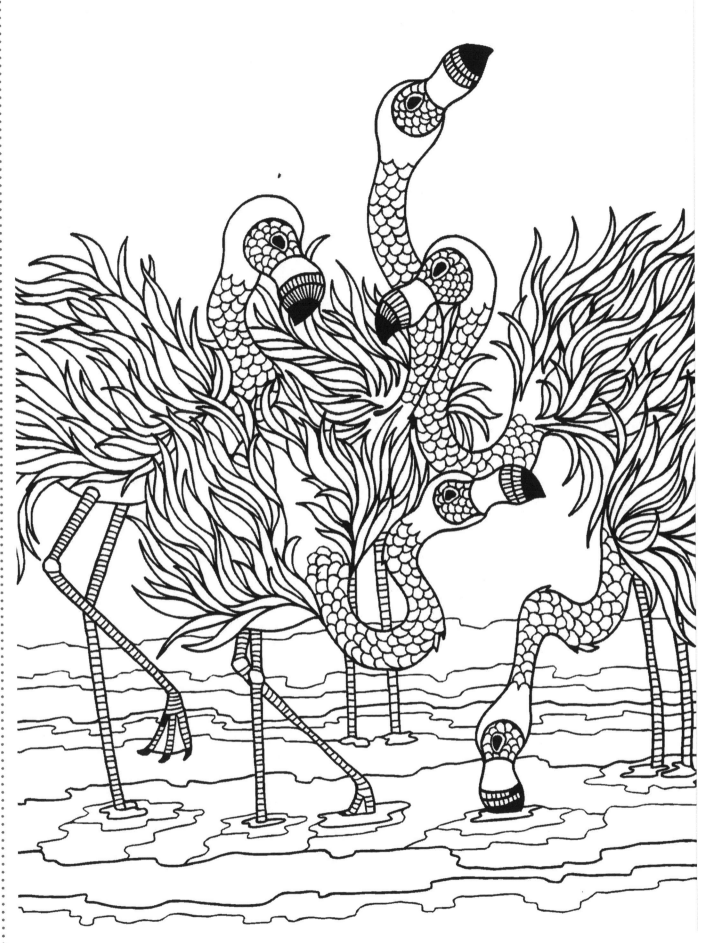
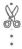

L ook deep into nature, and then you will understand everything better.

Albert Einstein

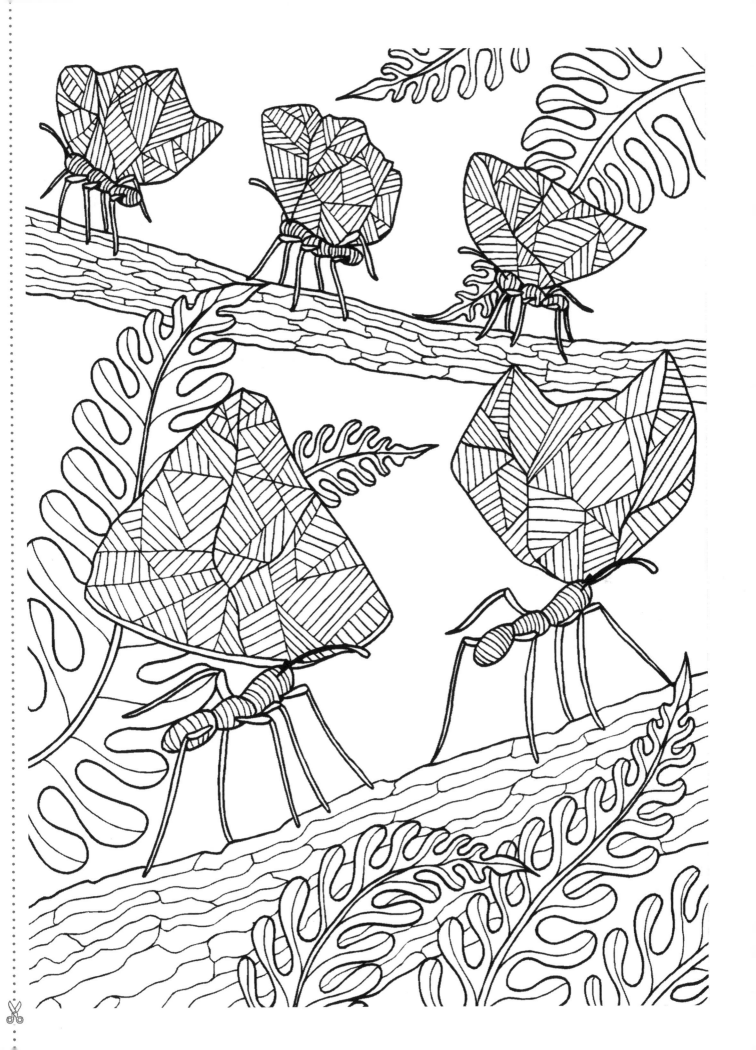

On earth there is no heaven, but there are pieces of it.

Jules Renard

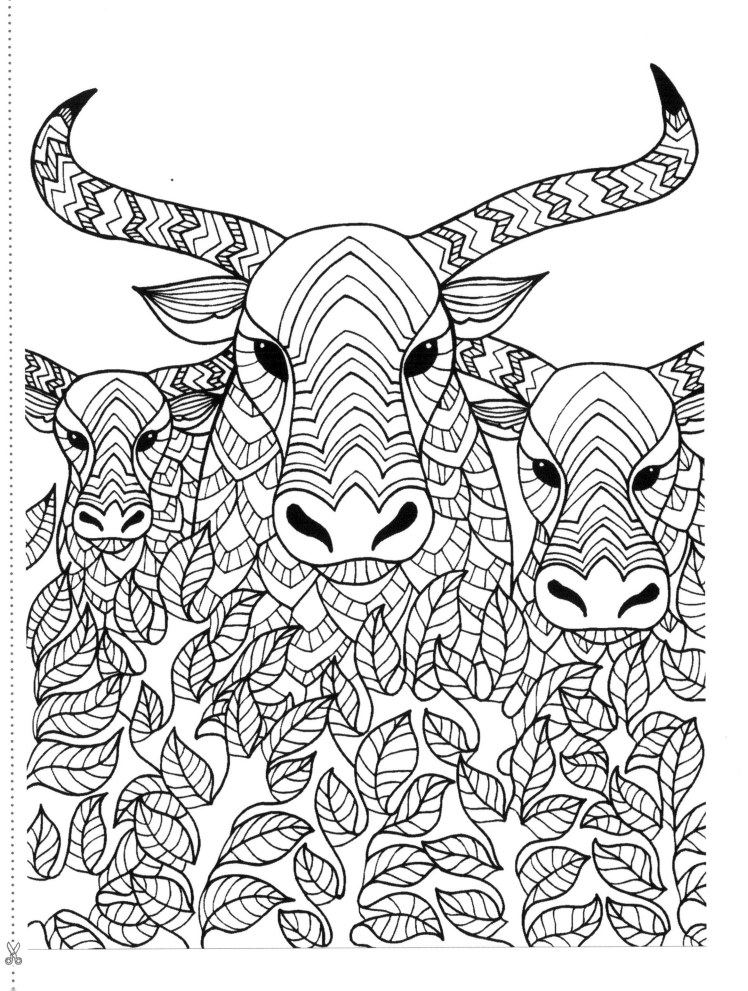

Every flower is a soul blossoming in nature.

Gerard De Nerval

Nature does not hurry, yet everything is accomplished.

Lao Tzu

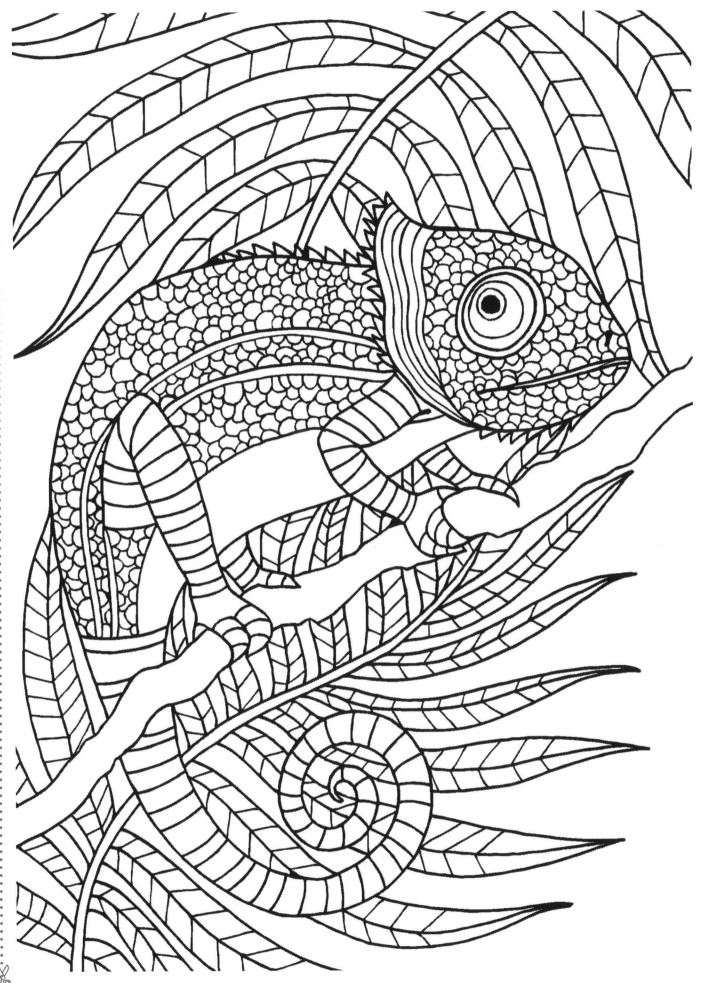

Just living is not enough... one must have sunshine, freedom, and a little flower.

Hans Christian Andersen

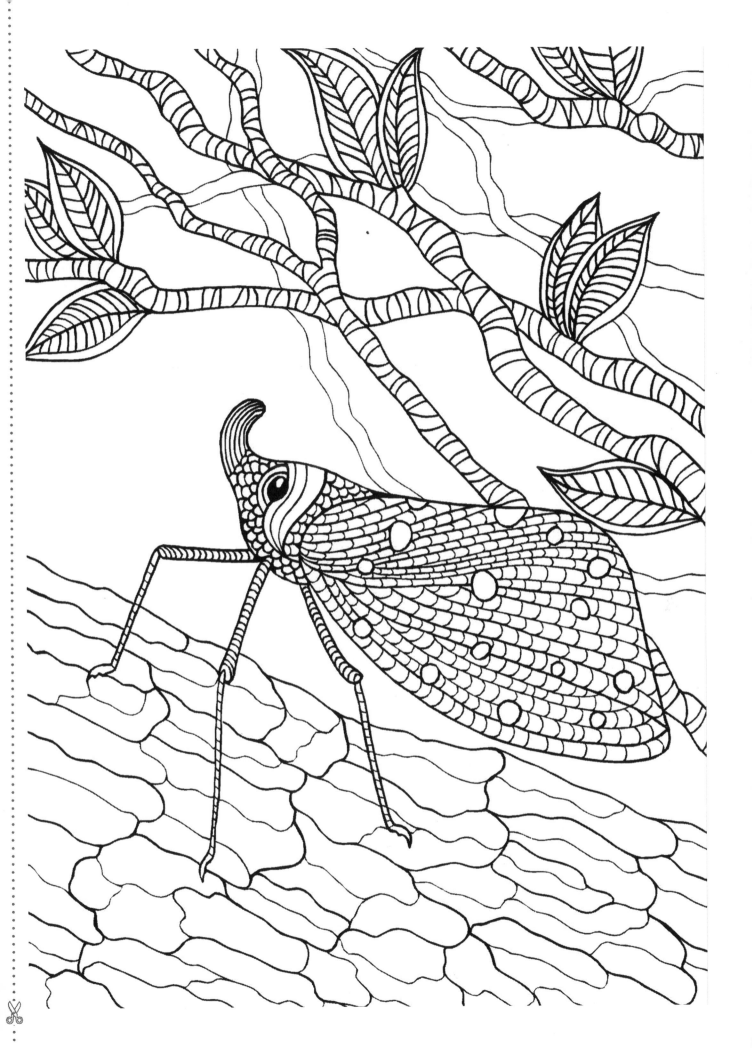

There is pleasure in the pathless woods, there is rapture in the lonely shore, there is society where none intrudes, by the deep sea, and music in its roar; I love not Man the less, but Nature more.

Lord Byron

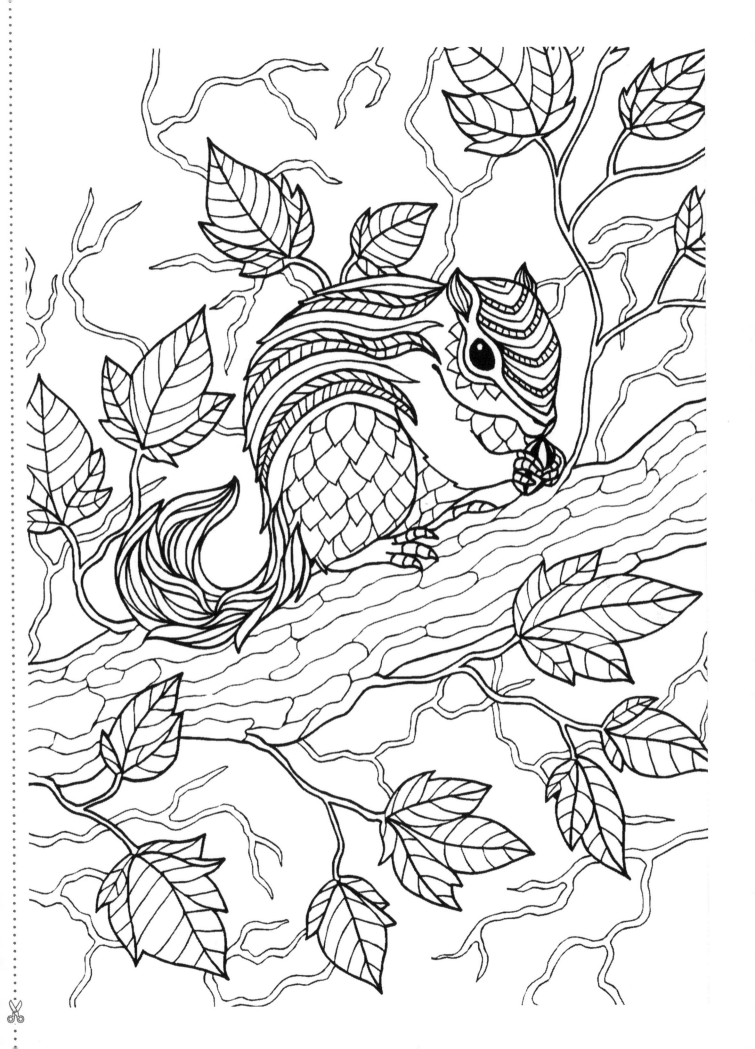

Earth and sky, woods and fields, lakes and rivers, the mountain and the sea, are excellent schoolmasters, and teach some of us more than we can ever learn from books.

John Lubbock

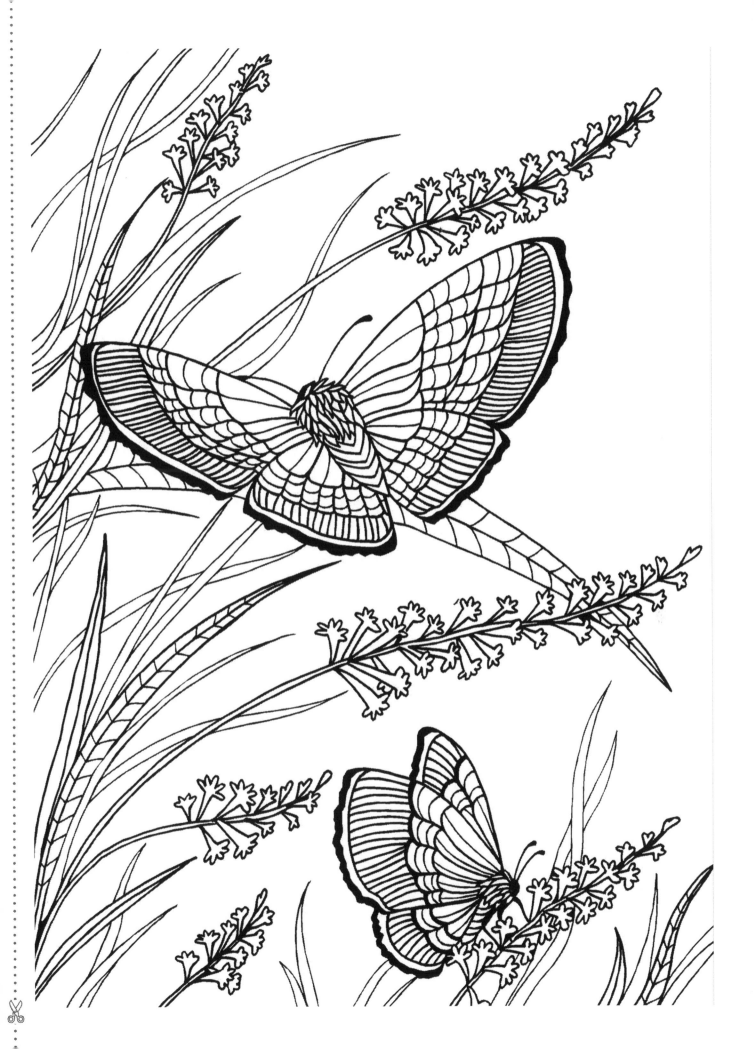

There are always flowers for those who want to see them.

Henri Matisse

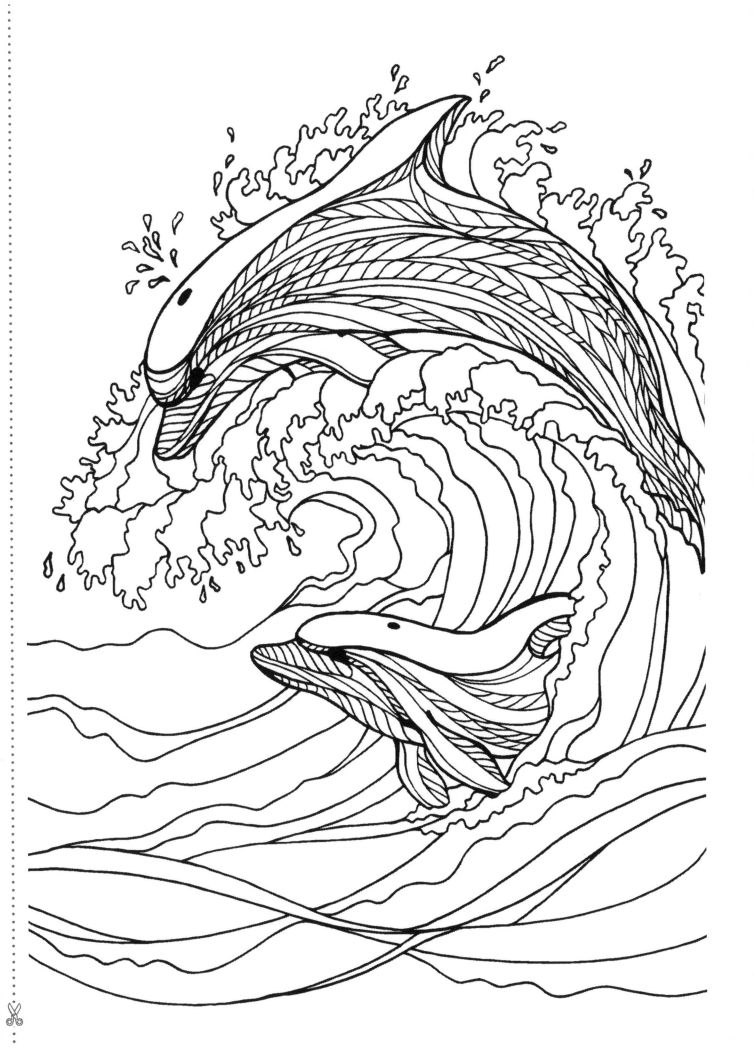

One touch of nature makes the whole world kin.

William Shakespeare

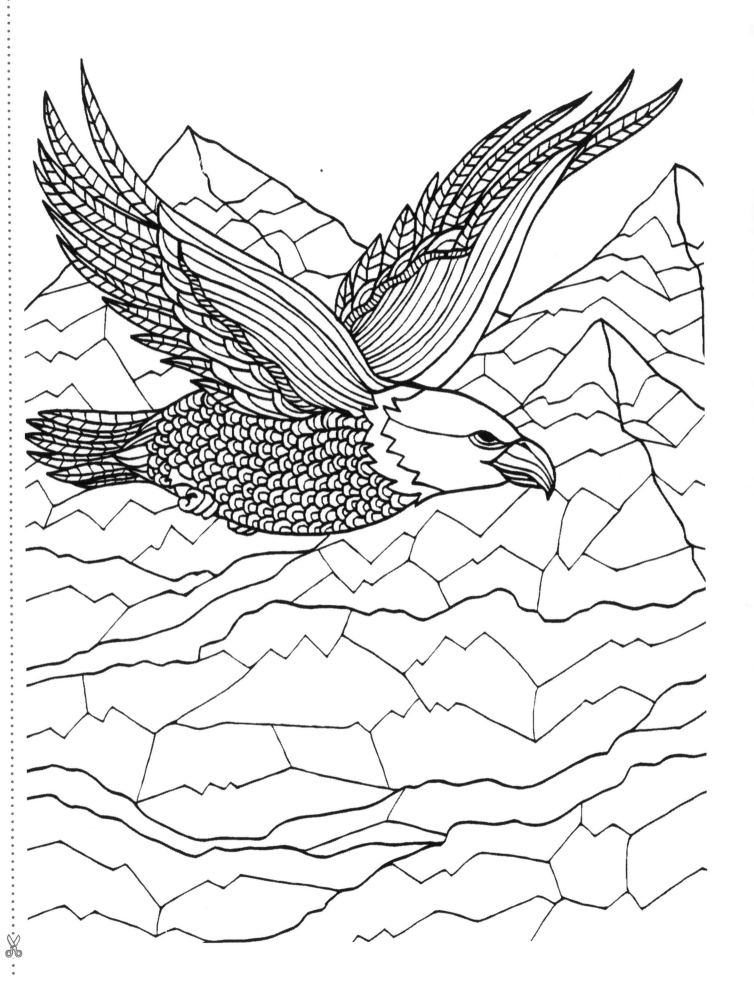

And the day came when the risk to remain tight in a bud was more painful than the risk it took to blossom.

Anais Nin

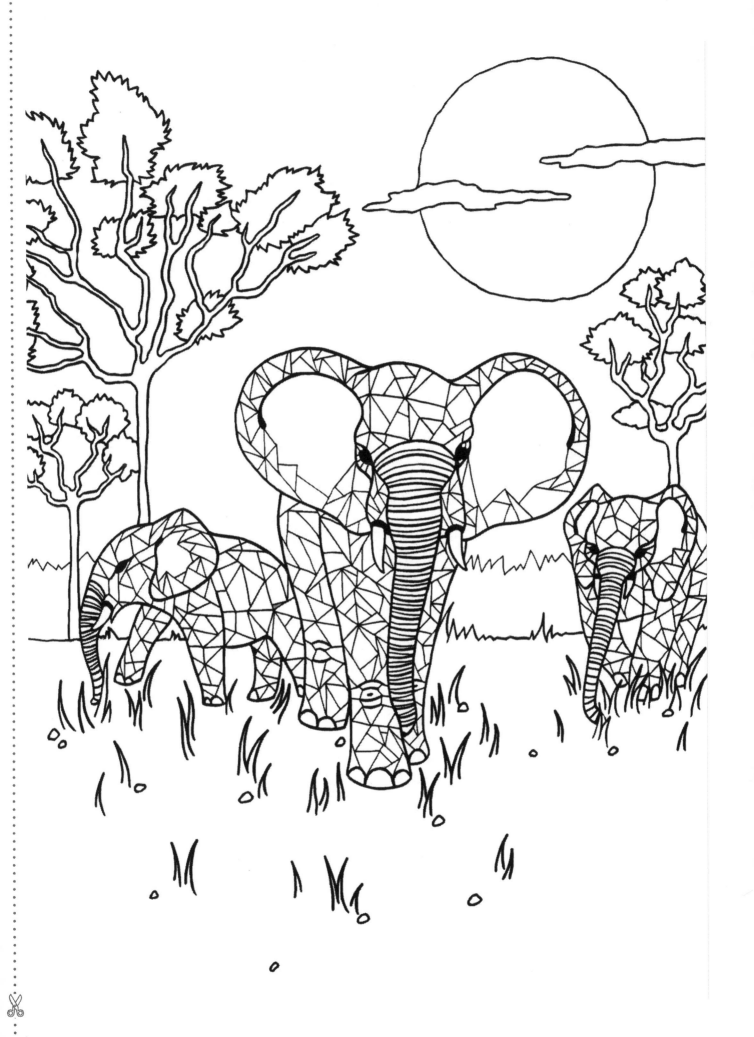

One of the most tragic things I know about human nature is that all of us tend to put off living. We are all dreaming of some magical rose garden over the horizon instead of enjoying the roses that are blooming outside our windows today.

Dale Carnegie

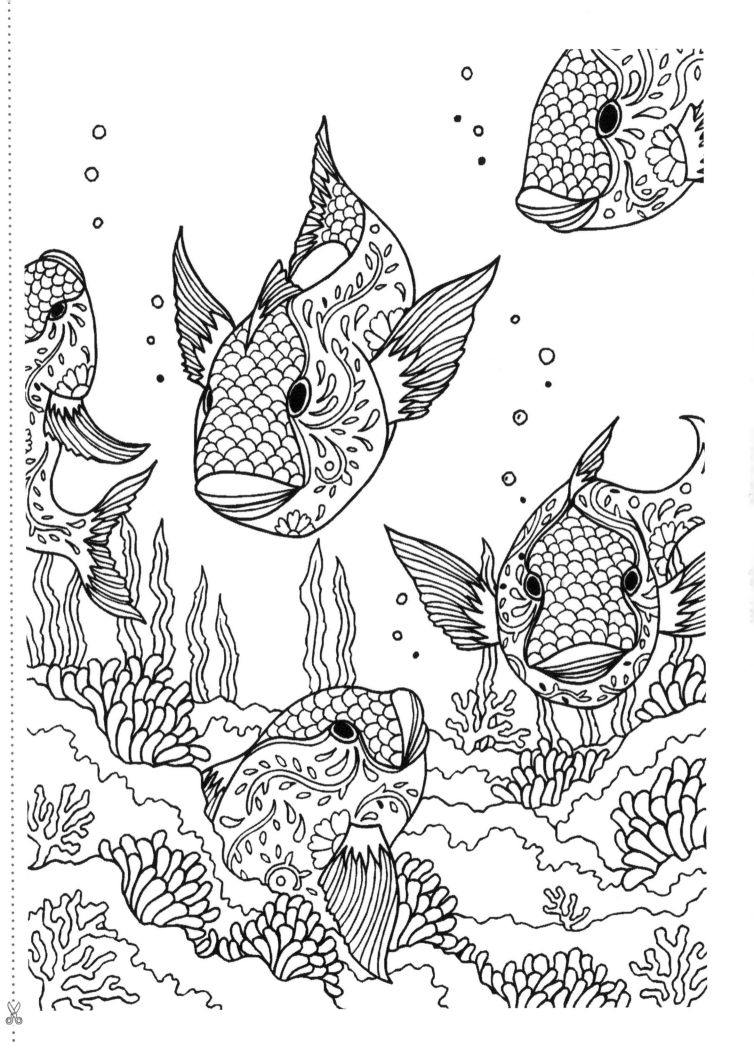

For my part I know nothing with any certainty, but the sight of the stars makes me dream.

Vincent Van Gogh

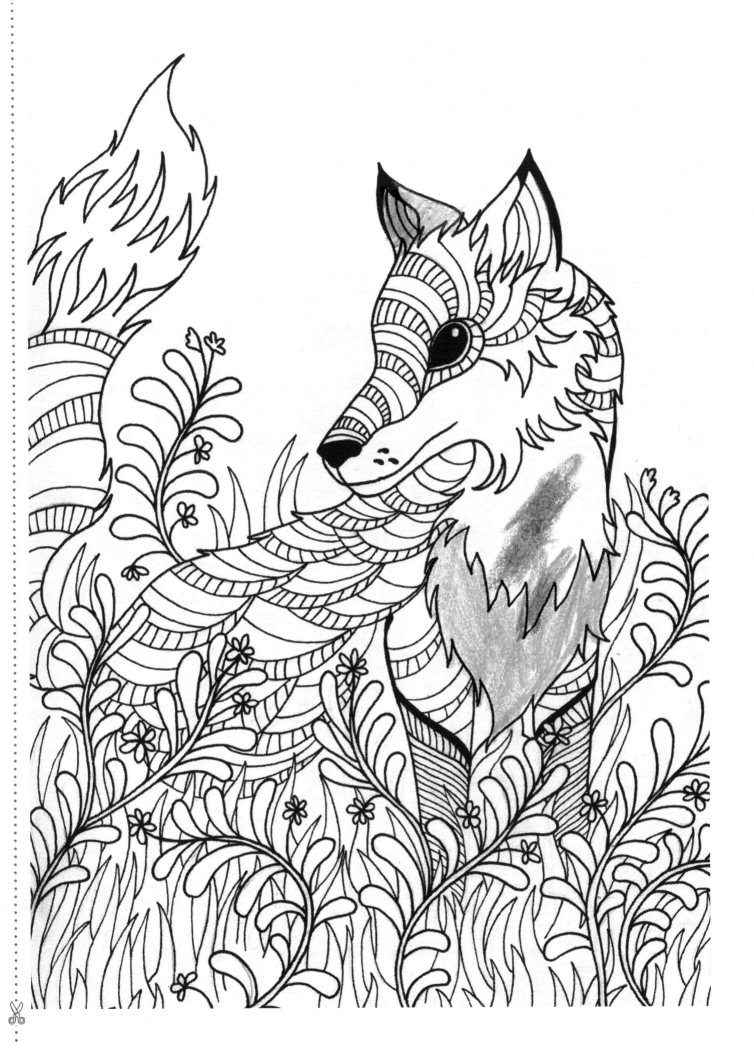

The clearest way into the Universe
is through a forest wilderness.

John Muir

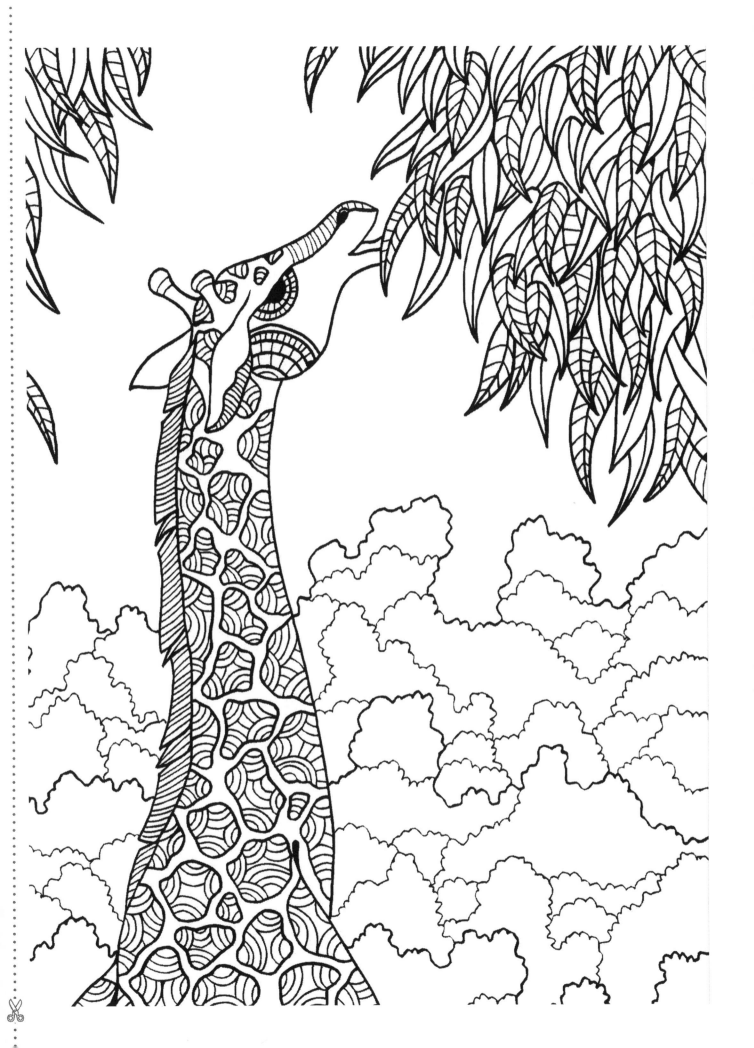

I wonder if the snow loves the trees and fields, that it kisses them so gently? And then it covers them up snug, you know, with a white quilt; and perhaps it says "Go to sleep, darlings, till the summer comes again."

Lewis Carroll

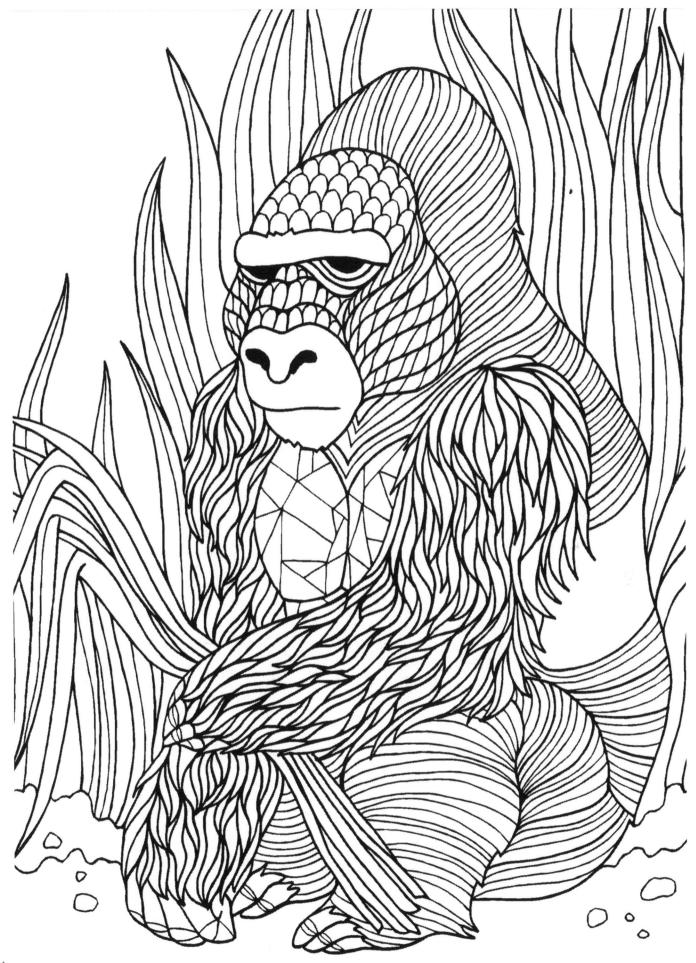

I like it when a flower or a little tuft of grass grows through a crack in the concrete. It's so heroic.

George Carlin

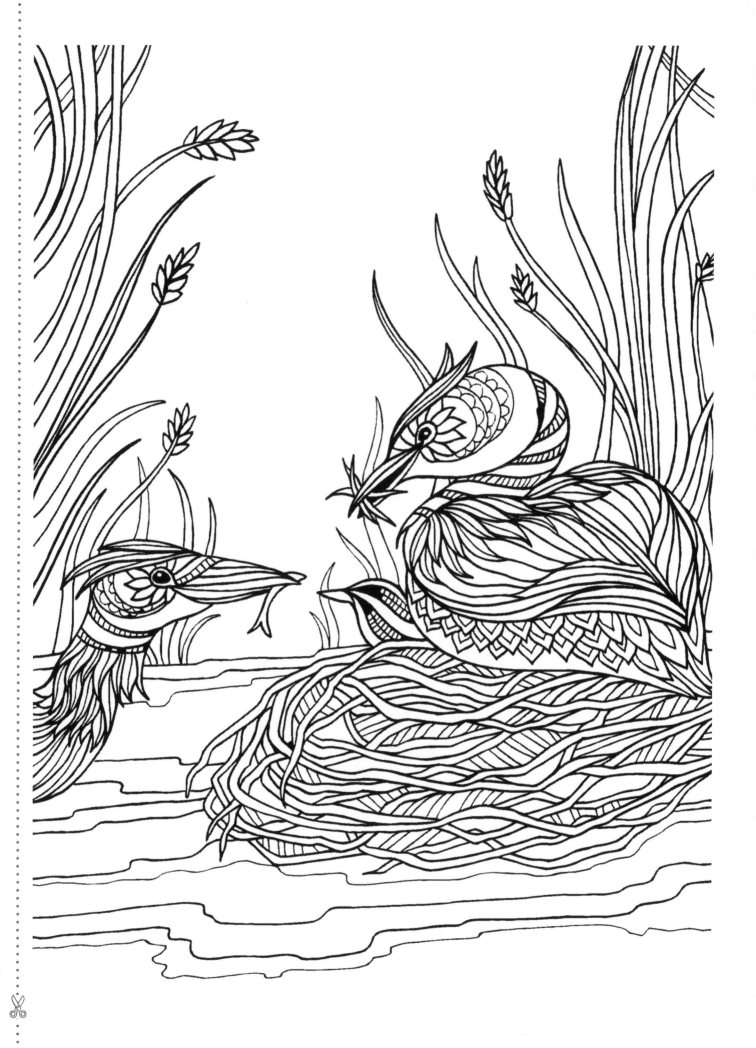

I felt my lungs inflate with the onrush of scenery - air, mountains, trees, people. I thought, "This is what it is to be happy."

Sylvia Plath

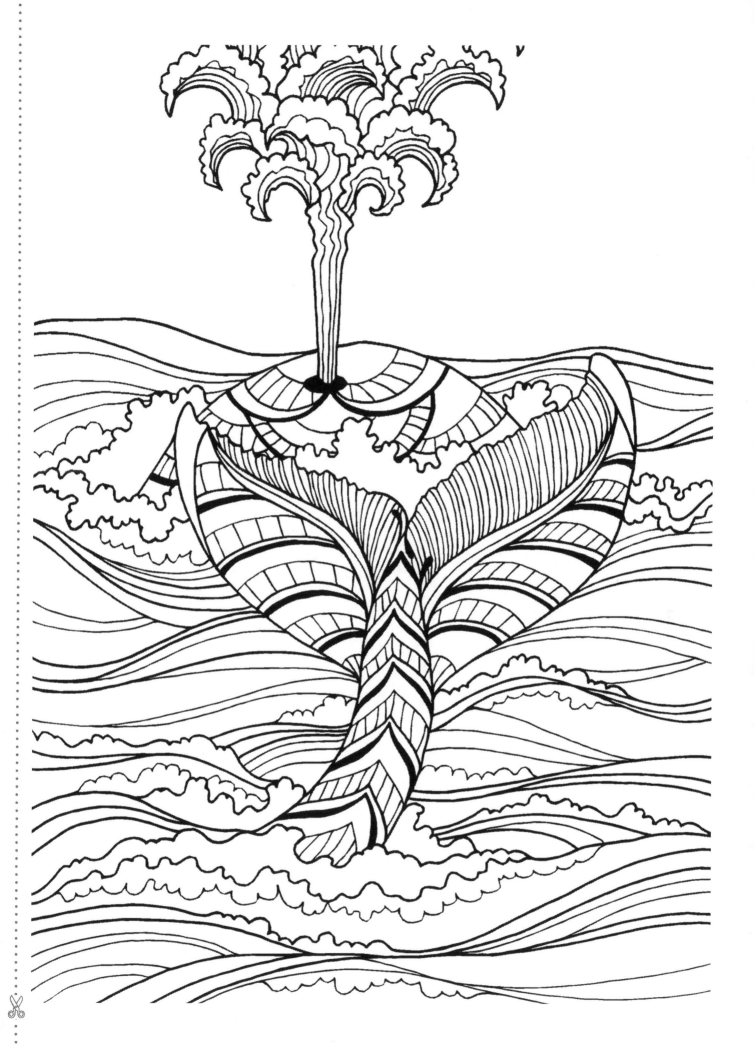

Nature's first green is gold,
Her hardest hue to hold.
Her early leaf's a flower;
But only so an hour.
Then leaf subsides to leaf.
So Eden sank to grief,
So dawn goes down today.
Nothing gold can stay.

Robert Frost

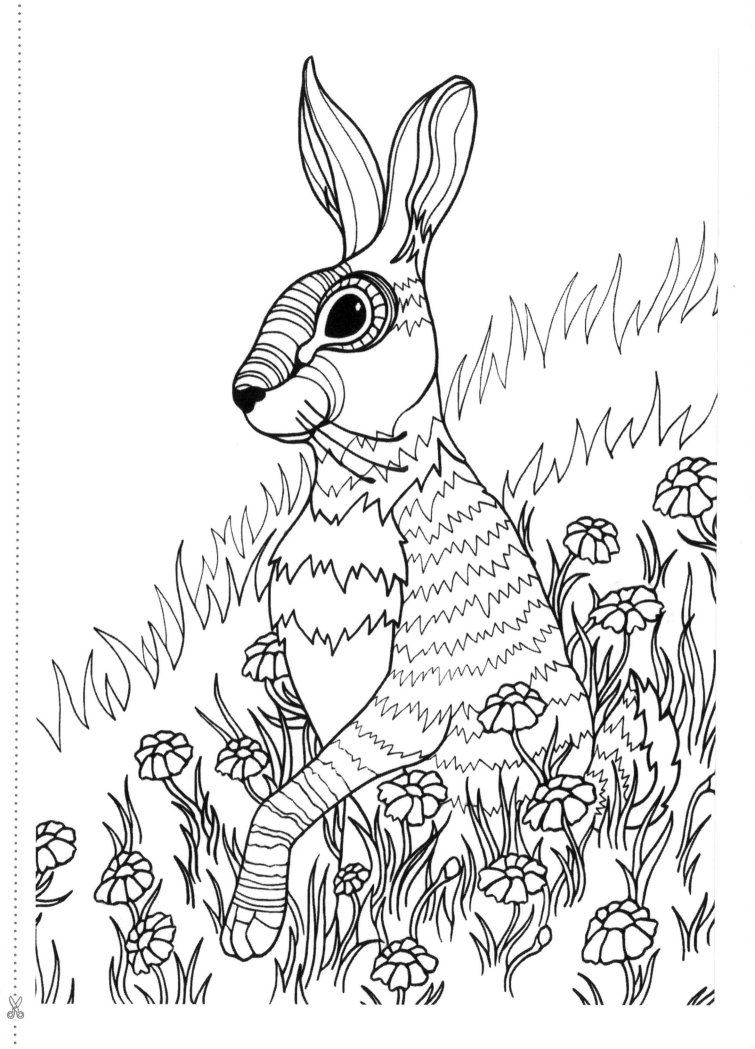

I know that then there will always be comfort for every sorrow, whatever the circumstances may be. And I firmly believe that nature brings solace in all troubles.

Anne Frank

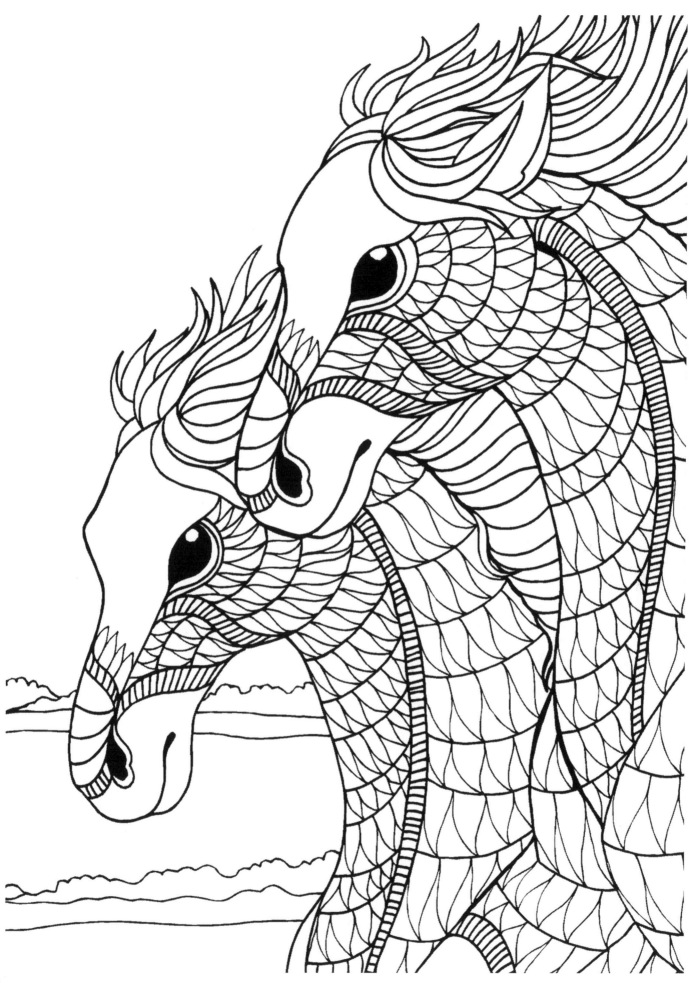

F

lowers are the sweetest things
God ever made and forgot to put
a soul into.

Henry Ward Beecher

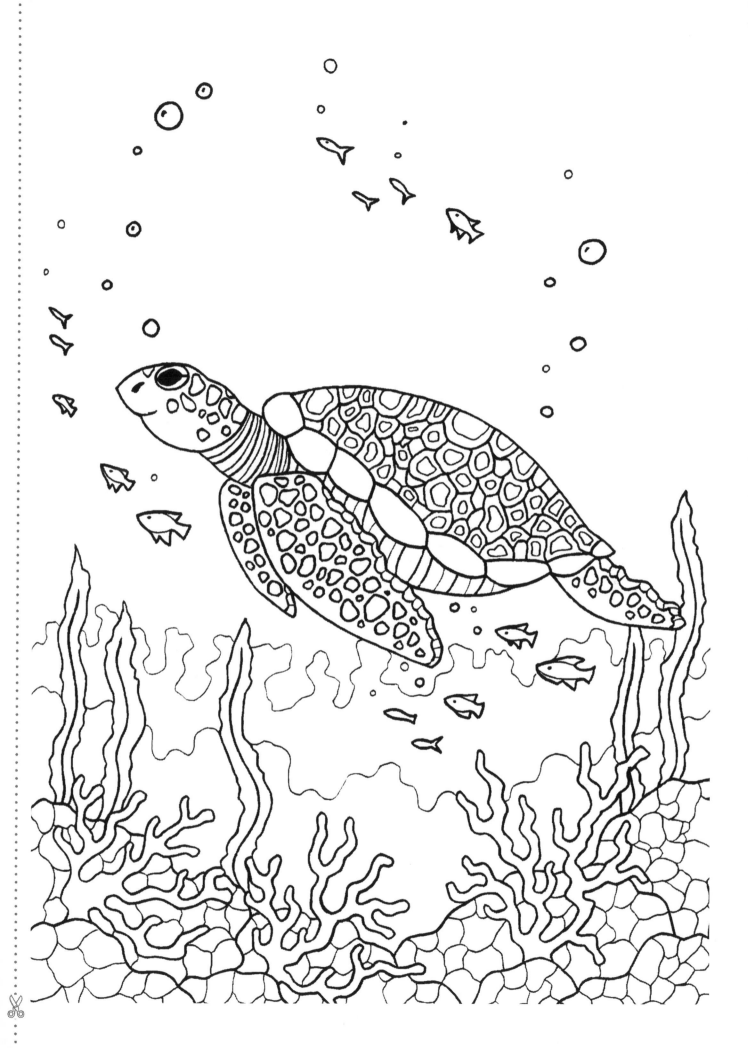

Should you shield the canyons from the windstorms you would never see the true beauty of their carvings.

Elisabeth Kübler-Ross

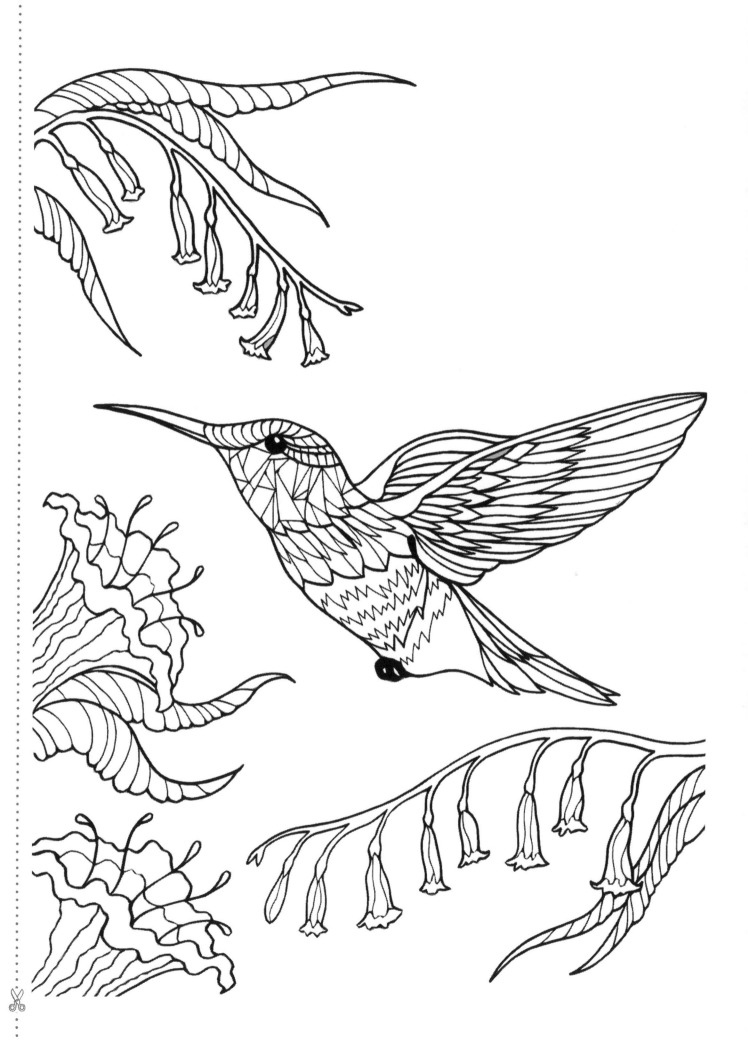

Adopt the pace of nature: her secret
is patience.

Ralph Waldo Emerson

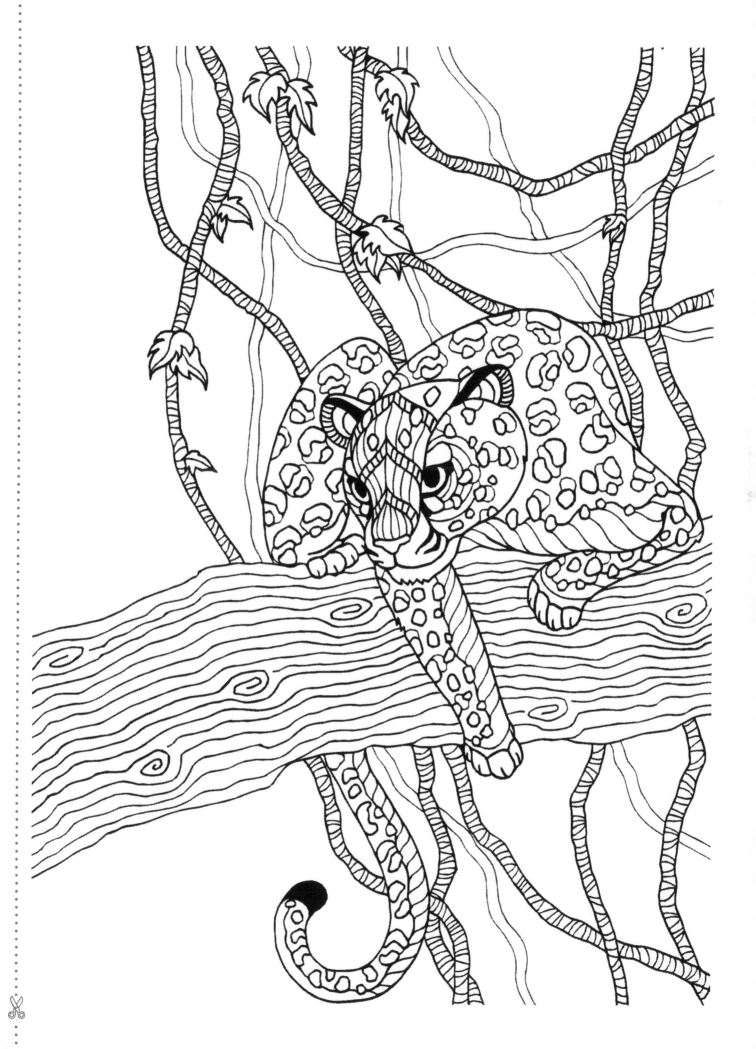

And then, I have nature and art and poetry, and if that is not enough, what is enough?

Vincent van Gogh

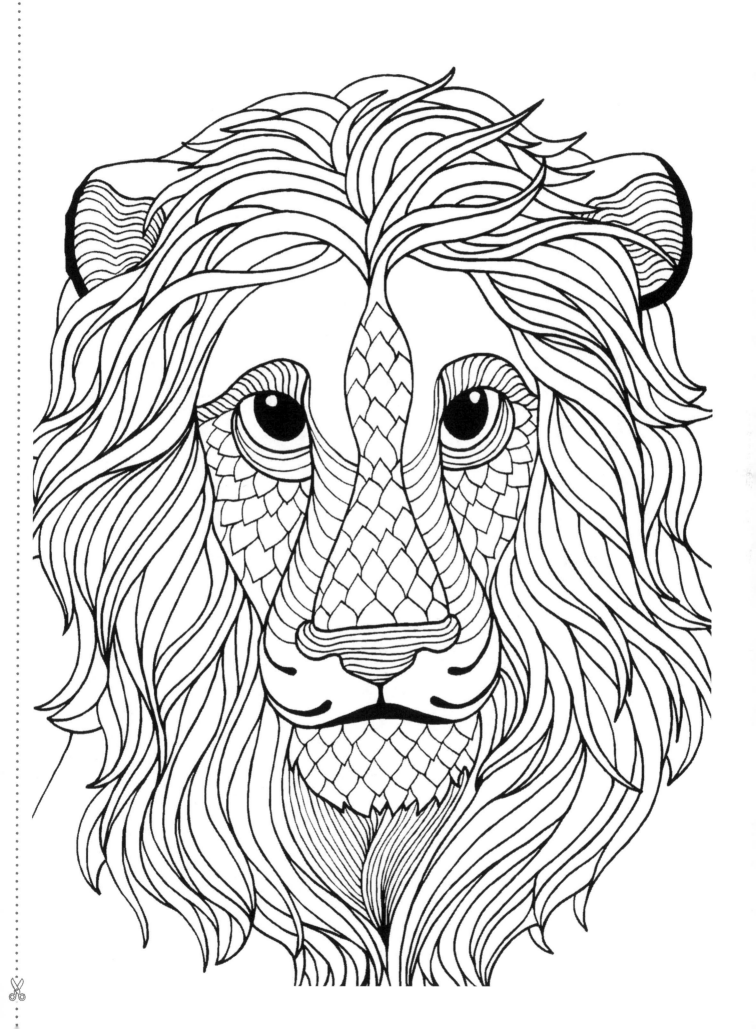

Plans to protect air and water,
wilderness and wildlife are in fact
plans to protect man.

Stewart Udall

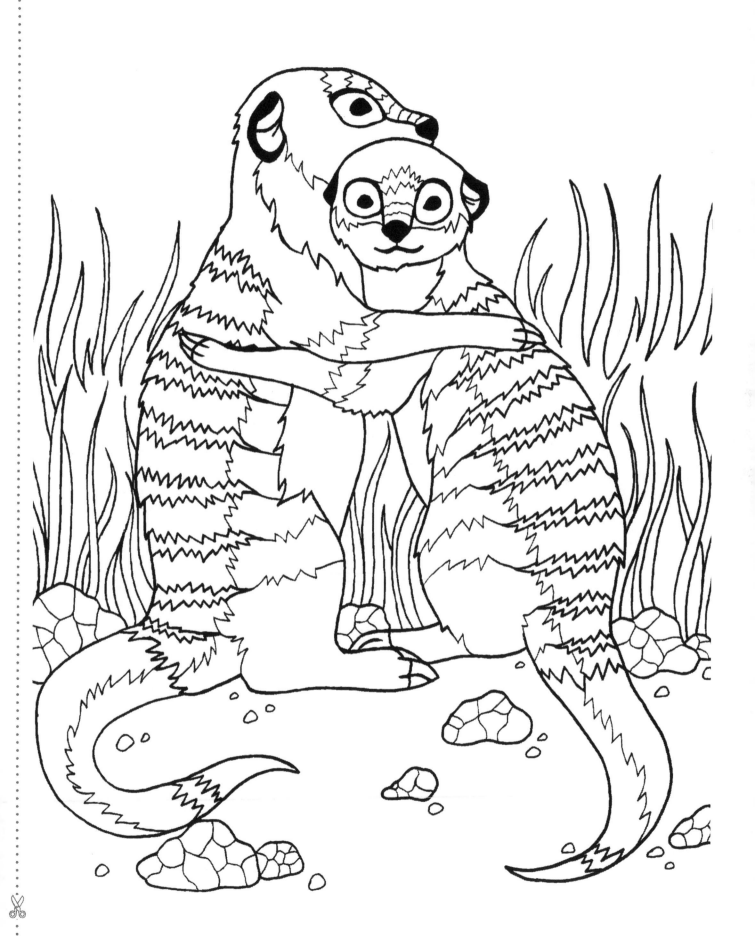

The quicker we humans learn that saving open space and wildlife is critical to our welfare and quality of life, maybe we'll start thinking of doing something about it.

Jim Fowler

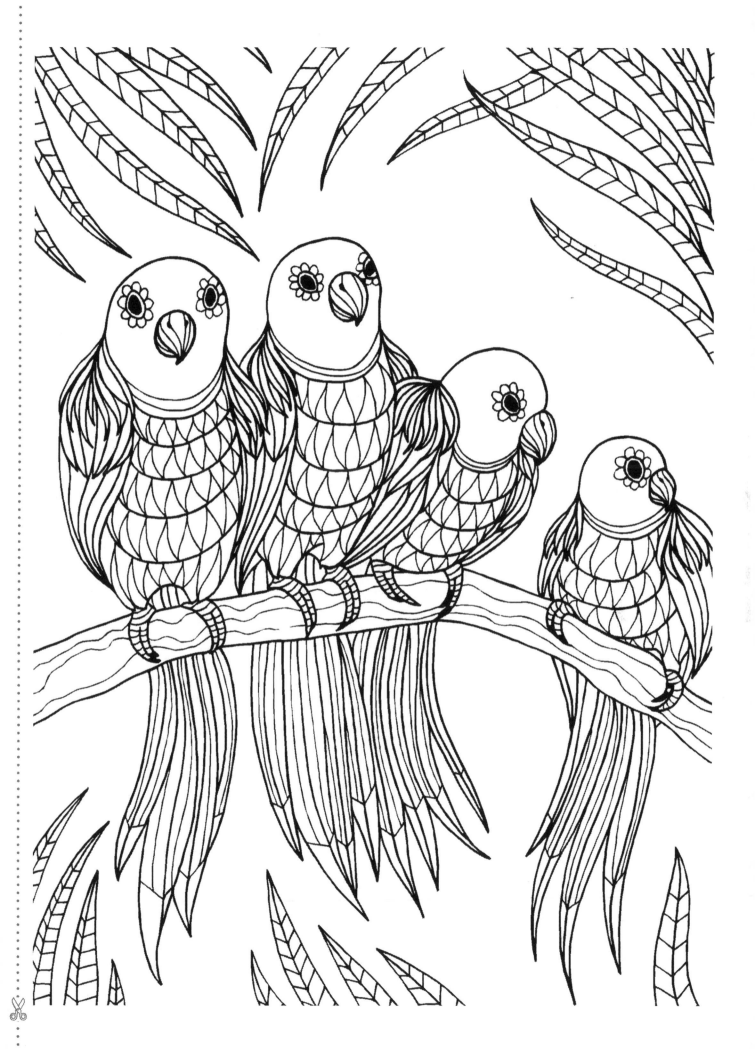

I feel like I'm nothing without wildlife. They are the stars. I feel awkward without them.

Bindi Irwin

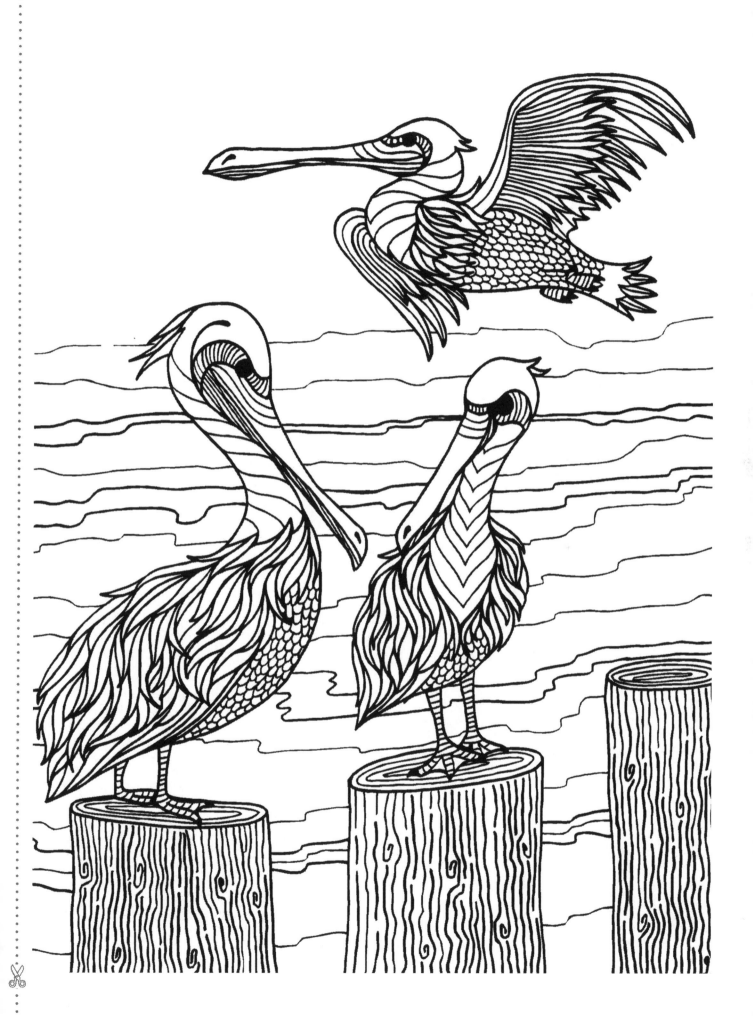

I

f you truly love nature, you will
find beauty everywhere.

Vincent Van Gogh

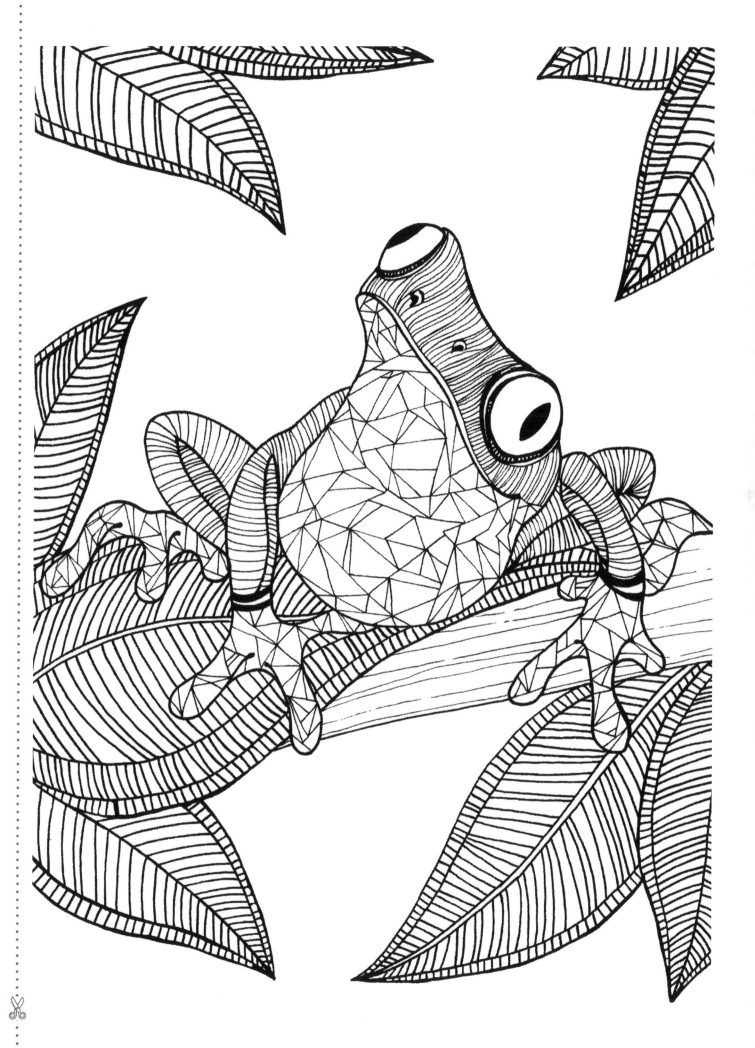

A lake is the landscape's most beautiful and expressive feature. It is Earth's eye; looking into which the beholder measures the depth of his own nature.

Henry David Thoreau

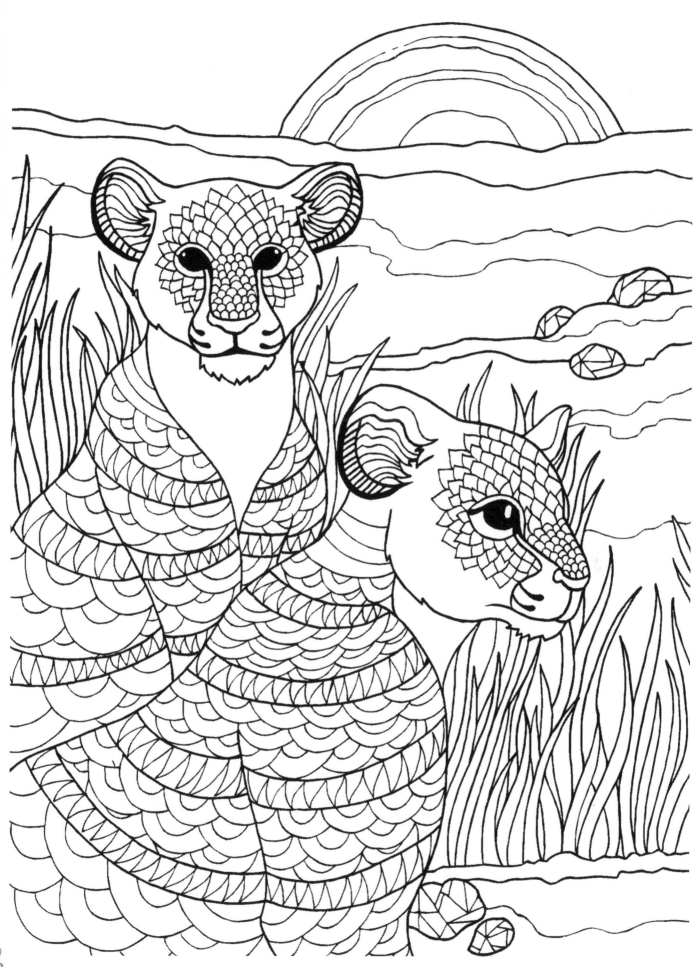

Climb the mountains and get their good tidings. Nature's peace will flow into you as sunshine flows into trees. The winds will blow their own freshness into you, and the storms their energy, while cares will drop away from you like the leaves of Autumn.

John Muir

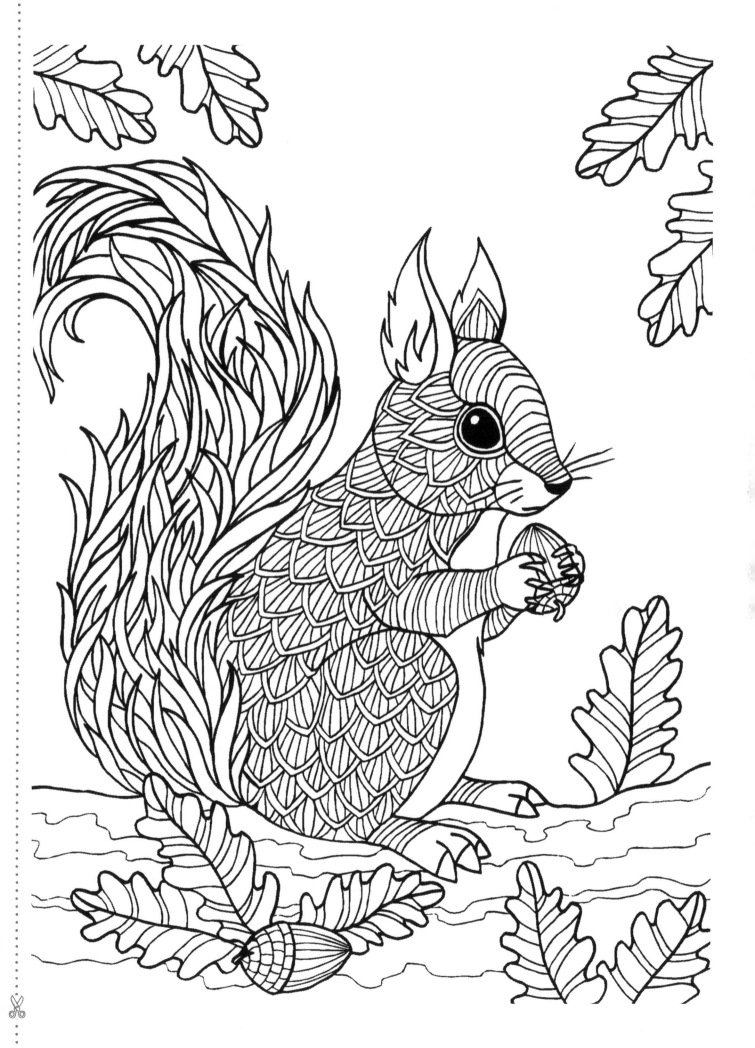

I go to nature to be soothed and healed, and to have my senses put in order.

John Burroughs

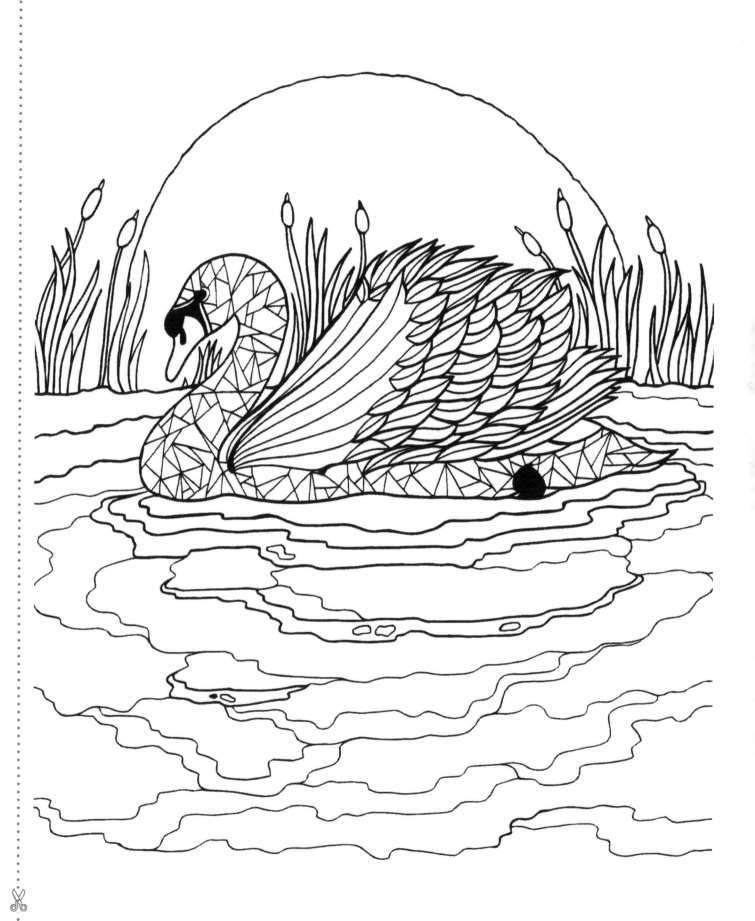

Nature never hurries. Atom by atom, little by little she achieves her work.

Ralph Waldo Emerson

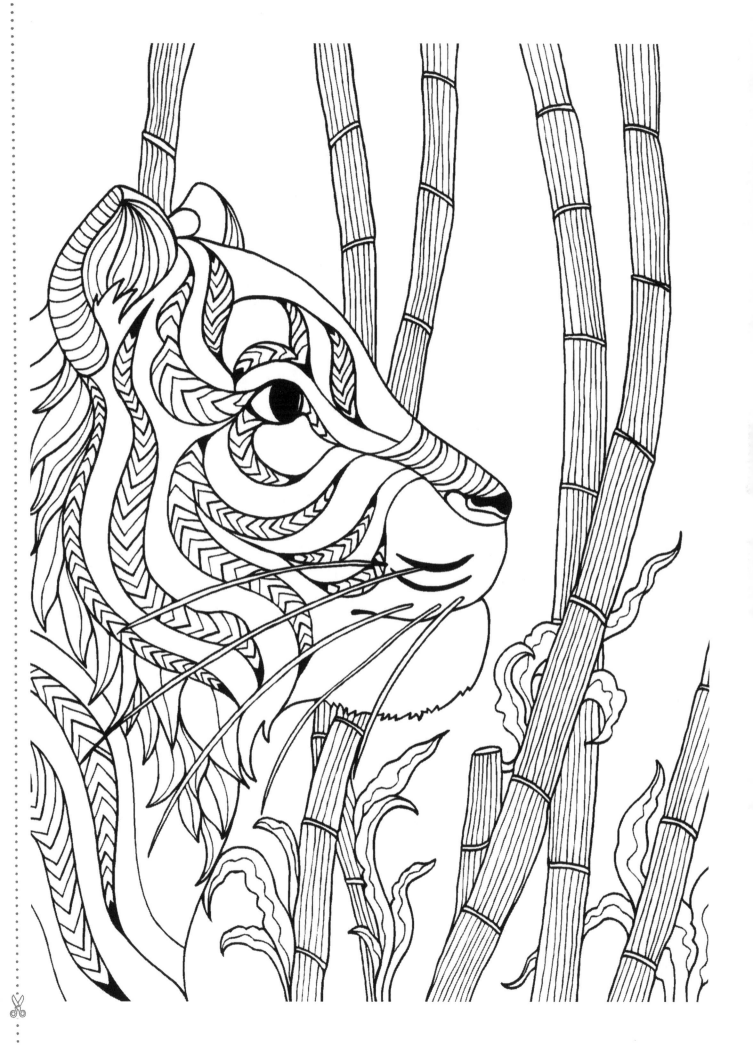

42878274R00037

Made in the USA
Lexington, KY
09 July 2015